DRAWING WILD ANIMALS

OANA BEFORT *and* **MAGGIE REINBOLD**

ESSENTIAL TECHNIQUES *and* **FASCINATING FACTS** *for the* **CURIOUS ARTIST**

QUARRY

Brimming with creative inspiration, how-to projects, and useful information to enrich your everyday life, Quarto Knows is a favorite destination for those pursuing their interests and passions. Visit our site and dig deeper with our books into your area of interest: Quarto Creates, Quarto Cooks, Quarto Homes, Quarto Lives, Quarto Drives, Quarto Explores, Quarto Gifts, or Quarto Kids.

First Published in 2018 by Quarry Books, an imprint of The Quarto Group, 100 Cummings Center, Suite 265-D, Beverly, MA 01915, USA. T (978) 282-9590 F (978) 283-2742 QuartoKnows.com

Quarry Books titles are also available at discount for retail, wholesale, promotional, and bulk purchase. For details, contact the Special Sales Manager by email at specialsales@quarto.com or by mail at The Quarto Group, Attn: Special Sales Manager, 401 Second Avenue North, Suite 310, Minneapolis, MN 55401, USA.

10 9 8 7 6 5 4 3 2 1

ISBN: 978-1-63159-349-9

Digital edition published in 2018

Library of Congress Cataloging-in-Publication Data

Names: Befort, Oana, author. | Reinbold, Maggie, author.
Title: Drawing wild animals : essential techniques and fascinating facts for
 the curious artist / Oana Befort and Maggie Reinbold.
Description: Beverly, MA : Quarry Books, 2018. | Includes index.
Identifiers: LCCN 2017053646 | ISBN 9781631593499 (paperback)
Subjects: LCSH: Wildlife art. | Drawing--Technique. | Animals--Miscellanea. |
 BISAC: ART / Techniques / Drawing. | ART / Subjects & Themes / Plants &
 Animals. | NATURE / Animals / General.
Classification: LCC NC780 .B36 2018 | DDC 743.6--dc23 LC record available at https://lccn.loc.
gov/2017053646

Design and Page Layout: Stacy Wakefield Forte
Cover Images and Illustrations: Oana Befort

Printed in China

FSC
www.fsc.org

MIX
Paper from
responsible sources
FSC® C101537

To Samuel and Emma,
may you always stay curious.
—OB

For Brad and Wren and Phoebe,
my fellow nature explorers
and the loves of my life.
—MR

Acknowledgments

I am so thankful that Joy Aquilino contacted me about illustrating this book, which features one of my favorite drawing subjects. What a beautiful opportunity! Thank you to Quarry Books and all its amazing staff, especially Marissa Giambrone and Cara Connors.

I am thankful for my amazing husband, Jeremy, for always believing in me and supporting my freelance work, for helping me thrive doing what I love while being a wife and a mother. Thank you for encouraging my passion and seeing beyond the countless art supplies and storage solutions!

Thank you, my beautiful kids, for your curiosity, love for all animals and creatures, and for the many zoo trips and countless hours of reading animal-themed books. I have learned so many things alongside you!

I would also like to thank my wonderful parents for giving me and my sisters the opportunity to explore the natural world and letting me follow my passion in the art field.

Last, I am grateful for Maggie Reinbold's beautiful writings, which coexist so harmoniously with my artwork and make the whole project come together.

—OANA BEFORT

I offer my genuine thanks to Joy Aquilino for inviting me to collaborate on this wonderful project and for her eternal patience. Researching and writing about these majestic species reminded me again why I love wildlife and why I will work for the rest of my life to conserve it. I am also extremely grateful to San Diego Zoo Global, most especially Allison Alberts, Ollie Ryder, and the entire Community Engagement team (a.k.a. League of Extraordinary Women) for supporting me in my professional and personal pursuits. How lucky I am to work for an organization with such an inspiring mission and such a bold vision! Thanks also to the San Diego Natural History Museum, Cardiff Elementary School, and the National Science Foundation for igniting my love of science teaching.

I would also like to thank Marshal Hedin, for inspiring me to pursue a career in biodiversity conservation; Michael Renner, for dragging me all over the great state of California; and Susie Arter, for sending me all over the world in the name of science (much to my mother's dismay). I also want to thank my parents for so frequently taking us out into nature as kids (from Redfish Lake to Silver Falls), and my sister, Jenna, for always disappearing on long hikes . . . you taught me that there is always more to discover (you are still teaching me that today!). Last, love and thanks to my husband and daughters for reminding me of what's most important in life and for always being up for adventures in nature. Here's to many more years of exploring!

—MAGGIE REINBOLD

CONTENTS

PREFACE 6

DRAWING TIPS AND TOOLS 8

MAMMALS

drawing predators
Bengal Tiger 16
Gray Wolf 19
Polar Bear 22
Yellow Mongoose 25

drawing grazers
Elk 30
Hippopotamus 33
Giraffe 36
Zebra 40
Rhinoceros 43

drawing elephants
African Bush Elephant 48

drawing burrowers
European Hedgehog 54

drawing rodents and rabbits
Chinchilla 60
Cape Hare 63

drawing sloths
Brown-Throated Three-Toed Sloth 68

drawing bats
Black Flying Fox 74

drawing primates
Squirrel Monkey 80
Ring-Tailed Lemur 83

drawing marsupials
Koala 88

AMPHIBIANS

drawing frogs and toads
Blue Poison Frog 98
Common Toad 101

drawing salamanders and newts
California Slender Salamander 106

REPTILES

drawing lizards and snakes
Gold Dust Day Gecko 116
Western Diamondback Rattlesnake 119

drawing crocs and the like
Nile Crocodile 124

drawing turtles and tortoises
Russian Tortoise 130
Green Sea Turtle 133

CONSERVATION AND VALUE 136

RESOURCES 142

ABOUT THE AUTHORS 143

INDEX 144

PREFACE

I'VE LOVED TO DRAW AND PAINT for as long as I can remember. All along, the natural world and its beautiful creatures have been my most important and personally satisfying source of inspiration.

As a professional illustrator, much of the artwork I create for my clients features flora; in my personal work, I also enjoy exploring a variety of fauna. Although my visual style is simple—some might call it naïve or folk-inspired—before I attempt to interpret an animal in pencil or paint, I work to develop a solid understanding of its underlying structure and various visual details. I relish the time I spend studying an animal, its attitude or posture, how it stands, sits, and moves, the texture of its skin or the markings on its fur, and its other special features. Taking time to focus and simply observe makes the drawing process much easier, as well as more exciting and deeply inspired.

The goal of *Drawing Wild Animals* is to take you back to basics, to help you learn how to look at a variety of animals, starting with their proportions, which are expressed in simple shapes. You'll then be able to build on that foundation by adding details, textures, and patterns, which, in addition to strengthening your drawing skills, will help you develop an attentive inner eye and appreciate each animal's unique beauty.

Although the step-by-step examples cover each featured animal's essential characteristics, your personal study, plus a lot of practice, will enhance your artistic abilities and are important aspects of your artistic journey.

In addition, through conservation educator Maggie Reinbold's beautifully written and informative text, you'll learn thought-provoking facts about each animal and its group or family, to give you a better understanding of its behavior and life in the wild.

I've truly enjoyed creating the instructional artwork in this book and put a lot of love into it. My hope is that you'll not only enjoy the information Maggie and I have created, but that you'll find something to spark your curiosity and enrich the challenge of drawing and painting each step.
Most of all, have fun drawing!

—OANA BEFORT

DRAWING TIPS AND TOOLS

LEARNING TO SEE

EVERY ANIMAL is unique and beautiful in its own way. To develop the skills needed to recognize and depict the specific attributes that exemplify each one, start by looking closely at photographs and videos and, whenever possible, observing animals firsthand, whether in a zoo or in the wild. As you carefully study an animal's proportions and characteristics and begin to see it as a whole, you'll be able to draw it with more confidence.

As you work through this book, you'll notice that all the drawing activities have one thing in common: To get each animal's basic proportions right, begin with basic geometric shapes and lines. Once you have the main outlines figured out, the details you add later will only complement those first steps.

Don't be afraid to sketch your subject more than once. The most important part of learning to draw is practice. The time you spend drawing, experimenting, and learning—especially if you do it on a regular basis—will make a huge difference and go a long way in improving your skills.

BASIC SUPPLIES

Many art supplies can be used to draw and paint animals. The ones I list here are those I've used to create both the step-by-step drawings for each animal as well as the more detailed drawings and paintings in this book.

› **PAPER.** I use hot press watercolor paper when I want a smooth surface, and cold press for a slightly rougher, visible (but still subtle) texture. The one you choose is a matter of personal preference. If you're uneasy about starting a drawing directly on watercolor paper, practice on photocopy or printer paper or in a sketchbook.

› **PENCILS.** Artists' graphite pencils are graded from 9H (which makes the lightest marks) to 8B (the darkest). To make thin, less visible lines that are easier to cover with watercolor paint, use pencils from 5H to H. For a stronger line, such as when you want to emphasize details or outline a finished drawing, use pencils from HB to 4B.

› **WATERCOLORS.** Transparent watercolor is perfect for creating washes, or transparent layers of color, to add dimension and texture to your drawings. Apply a thin layer of paint, let dry, and then apply another, if desired. Watercolors come in tubes, liquids, and pan sets, which are perfect if you're painting on the go.

› **GOUACHE.** For more opaque color, use gouache paints. For the illustrations in this book, I mainly used white gouache to create accents or details on top of my watercolor work.

› **BRUSHES.** To paint larger areas, use a no. 8 round watercolor brush. For details and paintings on a smaller scale, use no. 1, 2, or 3 watercolor brushes, and a 10/0 liner for extra-fine details. Also, don't forget a cup or jar of water for cleaning your brushes as you work.

› **PALETTES.** Palettes come in many shapes and sizes, so choose one that best fits your art practice. Watercolor pan sets usually include an area for mixing, so you might not need a separate palette.

MAMMALS

REPRESENTING the smallest class of vertebrate animals, with roughly 5,400 described species across multiple orders, mammals are an incredibly diverse and fascinating group. They range in size from tiny bats and mice to massive whales, united by the presence of hair, mammary glands, and unique brain and ear structures.

All mammals are *endothermic*, or "warm-blooded," with the ability to regulate their own body temperature through internal processes instead of relying on the external environment. Endothermy allows species to thrive and survive in even the harshest environments; consequently, mammals are broadly distributed across all habitat types throughout the world.

Mammals display an incredible range of lifestyles and food preferences, from arboreal insectivores to aquatic carnivores to fossorial (burrowing) omnivores. They vary greatly in their external ornamentation, from color patterns such as stripes and spots to structures on the head like horns and antlers. They communicate in a variety of ways, using scent, sound, and movement to relay information and interact with each other under myriad community structures, from solitary living to strict hierarchies.

All mammals give birth to live young, except for a few egg-laying species such as the duck-

billed platypus of Australia. The platypus and a handful of echidna species, collectively called *monotremes*, lay eggs like birds and reptiles, but most of the incubation occurs inside the mother's body, with young drinking milk immediately after hatching. In contrast to the monotremes are the marsupials, a group of mammals that give birth to live young, but the offspring are born extremely small and undeveloped. Newborn marsupials are essentially still fetuses, and must make their way to the safety of the mother's pouch, where they actively suckle milk and continue developing. Last, there are the eutherians, representing the majority of mammalian species, including well-known groups such as bears, cats, whales, rhinos, and monkeys. Eutherian mammals nourish their young inside a placenta, a specialized embryonic organ within the mother. They are born fully developed and, in many species, ready to compete and survive within a very short period of time.

One unifying mammalian feature that can be challenging to re-create is the presence of hair or fur on the body. Serving many purposes across species, from camouflage to thermoregulation, mammalian fur varies greatly in thickness, color, rigidity, and density. The way that sunlight falls on or through a lion's mane on a breezy day, for example, is difficult to reproduce, but also provides endless motivation to observe and study these majestic species.

Quick Guide to
DRAWING PREDATORS
..........................

Sketch the head and body with
simple circles; connect with light lines.

Refine the features of the head
and details of the feet.

Add fur, then stripes or other surface
textures or patterns as needed.

Add color and shading.

DRAWING
PREDATORS
on the hunt

THE ORDER *CARNIVORA* encompasses some of the world's most revered and majestic species, including cats, wolves, and bears. Members of this group are recognized by their sharp claws, powerful jaws, and shearing teeth, most notably the canines and carnassials that allow them to easily kill and consume their prey. Some species in this group are strictly carnivorous (like the cats), while others are considered more omnivorous (like the bears). A diet of meat provides more energy than plant material, so carnivores typically spend less time eating than do their herbivorous relatives. In general, members of this group are adept hunters with excellent hearing and sense of smell, and they actively establish and defend their territories.

Though most carnivorans are solitary, wolves represent a notable exception, working alongside one another in pack formation to outperform prey and survive in often harsh conditions. Bears thrive in a variety of habitats around the world, and most undergo hibernation during winter. Despite their bulky frames, they're surprisingly agile climbers and swimmers. Cat species are also widely distributed from desert to snow and are easily recognizable by their sleek and prominent musculature. The order *Carnivora* also includes commonly encountered species such as raccoons, skunks, and weasels.

› HOW TO DRAW ‹

BENGAL TIGER

Panthera tigris tigris

This beautiful large cat is very fun to draw. Once your main lines and shapes are defined, the distinct fur pattern can be wonderfully represented. The tiger's beautiful head and the high-contrast colors and striking stripes of its coat may take some practice to master.

The largest of all cat species, tigers swim, climb, and leap through forest habitats from the tropics of India to the snows of Siberia. Like most cats, tigers are solitary, strictly carnivorous, and depend on their stealthy camouflage and excellent vision, hearing, and sense of smell to stalk and ambush their prey.

1

Simplify the tiger into three basic circles: two for its body and one for its head.

2

To create the tiger's body, add lines that connect the circles. Add a tail that curves slightly at the end. Add a few guidelines for the paws, which are large with sharp claws, perfect for holding prey.

DRAWING WILD ANIMALS

3

Using the initial lines as guides, add the facial features and the ears, outline the body, and further refine the tail and paws.

4

Draw short lines across the body to suggest fur as well as volume and movement.

5

Refine the shape of the eyes with circles surrounded by a darker outline that extends toward the nose. Begin drawing dark lines on the face and then on the body.

MAMMALS

· 17 ·

6

Note that the tiger's stripes are quite symmetrical, wrapping around the body, and gradually become thinner toward the ends.

7

Add color to give the tiger a bit more personality and character, leaving some areas white: around the eyes, within the ears, and on the underside from the lower jaw to its belly.

› HOW TO DRAW ‹

GRAY WOLF

Canis lupus

Similar to, but not quite the same as, dogs, wolves make beautiful subjects to draw. Pay attention to their pointed black muzzle, pointy ears, strong legs with large paws, and thick bushy tail with a black tip.

Perhaps best known for their ominous multimember howling displays, wolves are highly social animals that rely on a complex set of behaviors, scents, and vocalizations to communicate and function as a tight-knit group, working cooperatively to hunt, defend territories, and raise young. Family packs are headed up by a dominant breeding pair, the alphas, who set the tone for interactions among group members and lead pack activities.

1

Draw two circles (they don't have to be perfect) with a light crayon as guides for the gray wolf's body and another circle for the head. The wolf will have a relaxed walking position, which is why the head will be positioned slightly lower than the body.

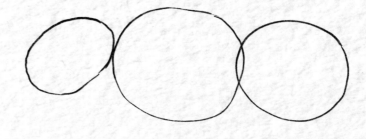

2

Unite the circles with lines that suggest the basic frame of the animal (mane, straight back, and reversed belly). Draw a few guidelines for the position of the legs with paws and tail. Draw a few lines to suggest the pointed muzzle. Notice that the backside is lower than the shoulders.

3

Using your initial guidelines,
refine your drawing even more.
Draw the ears that are some-
what pointy, find the position of
the (almond-shaped) eyes, and
refine the width of the legs.

4

Draw more fine curves around
the animal's body. The tail is
stiff, straight, and bushy. The
legs are muscular and hairy.

5

Suggest the wolf's thick fur by drawing sharp strokes along the body, especially on the tail. The eyes, nose, and lips of the wolf are black. Notice the paws and the long toes that end with strong, sharp nails.

6

Add a layer of warm gray over the body, except for the area under the snout/mouth and under the belly. You can leave those areas the white of the paper because they are usually a very pale gray.

7

Once your first layer of color is dry, you can add a few more layers to create more dimension. For example, the legs in the background are darker, as is the shading on the back of the head, inside the ear, under the tail, and at the tip of the tail.

› HOW TO DRAW ‹

POLAR BEAR

Ursus maritimus

Before drawing the bear (or any other animal, for that matter), you first need to get familiar with the animal's anatomy. The polar bear's body is large and furry, and you can suggest the beautiful white fur by the way you apply shadows and color.

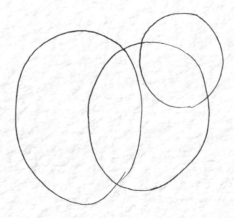

The world's largest terrestrial predator, polar bears are exceptional swimmers with an amazing sense of smell. They are distributed across an enormous range throughout the Arctic Circle and depend on sea ice as their primary habitat. Unlike other bears, they do not hibernate, though pregnant females do dig and reside in dens for up to eight months, during which time they gestate, birth, and nurse their cubs.

1

The bear's position will be slightly lateral, with its head facing us. Try to proportion the body by drawing two large circles with the first one slightly larger than the second. Draw a smaller circle for the head. All three circles will intersect each other due to the perspective of the body.

2

Draw a median line on the small circle to determine the middle of the head. Draw a line for the placement of the eyes and a smaller line for the length of the nozzle. Draw a few guides for the legs and paws. Draw one oval on each side of the head for the ears.

3

Refine the outline of the polar bear and the thickness of the legs, noticing that they are wide and furry. (Just like humans, bears have a *plantigrade* loco-motion, meaning that they walk on the soles of their feet.) Position the eyes as a small circle on each side of the head, and refine the muzzle and nose.

4

Slowly erase some of the initial pencil lines and add more volume to the body, suggesting some fur, as well. The bear's large paws have sharp claws.

5

Refine the lines and add more strokes that represent the fluffy fur of the bear, especially in the shade areas, if the light comes from the upper-left side.

6

To add shading throughout your drawing and to give it more dimension, add a soft layer of gray-blue color in the underneath areas. Polar bears are white, so representing that on paper can be quite challenging. Leaving some areas white and painting only some of the shade areas can give your drawing the right balance between white and shadow. You are, in fact, using shadows to determine your shapes.

7

Optional: You can further develop your drawing by adding more layers of color and fur strokes with your paintbrush. Use a soft wash for the outline of the body instead of the pencil drawing.

YELLOW MONGOOSE

Cynictis penicillata

Fun to draw, this furry animal has a slick, agile body. He is quite cute, with an interesting long face, slim torso, and bushy tail.

Distributed across a large range in southern Africa, the yellow mongoose is a highly social and territorial species that prefers open, arid habitats, often living adjacent to ground squirrels and meerkats. Strictly carnivorous, it feeds primarily on arthropods but will also opportunistically take larger vertebrate prey, such as birds, reptiles, and amphibians.

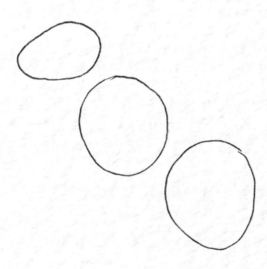

1

Just as in the previous examples, the first step consists of drawing the circles that form the main body areas of the animal.

2

Draw the guidelines that form an outline of the mongoose, focusing on the arch of the back, the neck, the positioning of the legs, and the tail.

3

Continue sketching the other parts of the mongoose, such as the visible ear (like a triangle with a round end), eye (almond shaped with a round circle in the middle), nose, and snout (quite flat). Sketch the legs with their width and define the paws.

4

Outline the whole body, reinforcing the basic lines and curves, and draw the tail. Notice that the tail is quite thick, strong, and furry.

5

Add fur details by using shorter pencil strokes on the body and longer ones on the tail.

6

Add more personality and
volume by applying a layer of
brown-orange. Leave the area
under the mouth, the neck,
the belly, and the tip of the
tail white.

7

Once your first layer of color is
dry, add more details, fur strokes,
and shading to gradually cover
your initial pencil lines.

Quick Guide to
DRAWING GRAZERS
· · · · · · · · · · · · · · · ·
Start with basic shapes.

Join the shapes with curved lines.

Use short lines to add texture
and volume.

Capture surface details.

Add color.

DRAWING
GRAZERS
on the hoof

FROM THE TINY royal antelope to the towering giraffe, hoofed mammals, also known as ungulates, are native to almost every region of the world. Most ungulates possess excellent hearing and sense of smell and have eyes situated on the sides of the head to provide sweeping views of the surrounding landscape, necessary survival traits for species of prey. Many also display impressive head ornamentation like horns, antlers, or ossicones, with most present only on males.

Most ungulates are strictly herbivorous, with only a few species considered omnivorous (such as pigs). Although most ungulates have multichambered stomachs to support rumination, a special process of internal fermentation that allows them to more easily digest plant material, a few have simpler stomachs and instead conduct fermentation in the intestines.

Unlike most other groups of animals, hoofed species, like cattle, horses, and pigs, have been uniquely connected to humans for centuries through the process of domestication and represent a critical source of food, labor, and livelihoods. Conversely, other ungulates face increasingly uncertain futures at the hands of humans—most notably rhinos and giraffes, both of which are actively poached in the wild and currently threatened with extinction.

› HOW TO DRAW ‹

ELK

Cervus canadensis

With their regal and dramatic antlers and furry manes, elk make exciting drawing subjects. Their body shape and proportions are like those of a horse.

1

Begin with a few basic shapes. Draw two large circles for the elk's body; the one for the hind flank is slightly smaller. Draw a smaller circle for the head.

2

Draw the main parts of the elk's body as basic geometric shapes to use as guides for the proportions and for developing details later.

3

Add the elk's nose and the basic position and outline of the antlers.

4

Outline the body by tracing the
main shapes. Add the eyes, nose,
mouth, and tail.

5

Erase the first guide shapes and
refine the antlers.

6

Draw slightly curved lines to
create the texture for the elk's
rich mane, which extends from
right beneath its head, all the
way around its neck, and down to
its chest.

7

Add a light wash of watercolor,
ink, or gouache to give the body
dimension. Apply a darker wash
to the mane.

› HOW TO DRAW ‹

HIPPOPOTAMUS

Hippopotamus amphibius

Well known for its large frame and love of water, this animal has a lot of curves. You can add more volume and texture by adding some color, as well.

Widely considered the most dangerous and aggressive mammal in Africa, the hippopotamus is perfectly built for life in the water. With major sense organs situated on the top of the head, hippos can hear, see, and smell with all but their heads submerged, a smart design for an animal that breeds, births, and sleeps in the water, emerging only to graze on nearby grasses.

1

Draw two circles as guides for the hippo's body, one for the head and one for the muzzle.

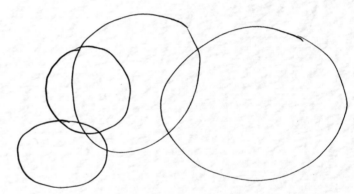

2

Draw a series of lines that slightly define the shape of the body (bulky and plump), and locate the middle of the head according to the body's perspective. Sketch the location of the short, stumpy legs.

3

Draw one round eye on each side of the head and a few lines surrounding the eyes as well as the protruding eye sockets. Draw two thin, oval ears, the nose, and the mouth as a line that curves up and in toward the hippo's eye. Notice the construction of the legs: each foot has four webbed toes.

4

Draw a few curved lines throughout the head and body to represent the folds of skin. Refine the legs, as well. The hippo has no hair, except a bit around the mouth and the tip of the tail.

5

Add more details to your drawing by maybe suggesting some skin spots and defining more skin folds. Draw some grass in the hippo's mouth and a suggestion of short grass on the ground that the hippo is standing on.

6

Add a layer of brownish gray color to your drawing, leaving some upper areas of the body white. This will suggest a slight shine and volume of the body.

› HOW TO DRAW ‹

GIRAFFE

Giraffa camelopardalis

The world's tallest land animal, the giraffe is intriguing to draw. It's fun to represent the beautiful pattern of the mosaic-like spots on its neck and body.

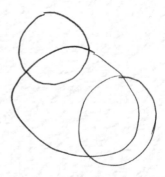

The giraffe is an iconic African image, with large gregarious herds wandering gracefully across the savanna. From a distance, they are best recognized by their long necks and spotted coats, but closer observation reveals the prominence of their luxuriant eyelashes, bony ossicones, or horns, and long, prehensile tongues.

1

Start by drawing a few circles that will define the giraffe's body and a circle as a base for the neck. Draw a small oval for the head, higher for a long neck.

2

Draw a diagonal line that connects the head to the body and sketch a few lines for the position of the legs and tail.

3

Draw an arc on the left side of the head oval as a guide to the giraffe's long muzzle. Draw the ears and a series of curved lines that connect the long neck to the body. Sketch the body and each of the giraffe's thin, long legs, with a small hoof at the end.

4

Draw the basic lines around the body and add details such us the giraffe's horn-like ossicones (a very distinctive trait), round eyes, short mane, and bushy tail. The base of the giraffe's leg should be thicker, and the joints are bumpy, as they connect the long, thin bones.

5

Refine your main outlines. Notice details such as the construction of the large eyes (see Tip), the furry ossicones, the darker muzzle, and the spots. Meant for camouflage, the spot pattern on each giraffe is unique; some are more complicated, depending on the giraffe subspecies. The giraffe's spots look much like a mosaic tile pattern, with large spots on the body that get smaller toward the head and joints.

6

Once all the main lines are established, add a light layer of color. Use a soft cream or light brown. Let dry.

7

Apply a few shades to the body to add volume. Add a darker brown to the muzzle, the mane, the tip of the tail, and the hooves.

8

Paint/fill in the spots on the giraffe with a chestnut brown that gets a bit lighter toward the belly and legs. Refine any other details on the body, like adding a few darker strokes of brown on the mane or tail, for example.

› **HOW TO DRAW** ‹

ZEBRA

Equus quagga burchellii

A beautiful animal with a distinctive pattern and mane, the zebra looks like a horse or pony. It's a good example of a monochromatic creature with a bold pattern.

1

Start by drawing two circles for the body and a small oval for the head.

2

Draw connecting lines between the circles to define the outline curves of the body. Add the oval shapes for the ears, and sketch the legs and their positioning.

3

Draw the zebra's muzzle with the oval nose, the mane along the head and neck, and the tail. Add more details to the body. The base of the legs, especially the ones in the back, is thicker, the joints are bumpy, and the lower part of the legs is thinner.

4

Continue finalizing the main shape of the zebra, adding more details to the eyes, mane, and tail, which has long hair at the end. Define the bumps near the bottom of the lower joint and draw a triangular shape for the hoof.

5

This is the fun part—but it takes a bit more patience. Each zebra has an individual set of stripes, and none is the same. Plus, zebras are actually black with white stripes. The stripes are thick along the body and placed vertically along the curves; they are thinner on the face, surrounding the eyes. At the same time, the stripes get thinner the farther down the leg they go. The pattern also continues into the zebra's mane.

6

Add a few light color washes in a light cream-gray to suggest volume of the zebra's body.

7

Once your first layer is dry, add more color details on the body, filling in the stripe pattern. The muzzle is all black, as are the end of the tail and the hooves.

› HOW TO DRAW ‹

RHINOCEROS

Rhinoceros unicornis

Looking a bit like a dinosaur, this gray
animal is fun to draw, with its two nose horns,
heavy frame, and thick, wrinkly skin.

Rivaled in size only by the elephants, rhinos roam boldly
through the wilds of Africa and Asia. Their thick, plated skin
resembles an impenetrable suit of armor, but is actually quite
sensitive, especially to insects and sunburn, which justifies
their favorite pastime of wallowing in mud. All five extant
species are critically endangered due to poaching for their
horns, either for ornament or perceived medicinal benefit.

1

Draw a few ovals as guides for the
rhino's body and an oval for the head.

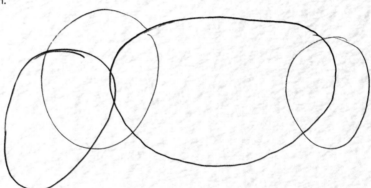

2

Sketch a few lines to help you place
the facial features in the right spot.
Sketch an outline of the major curves
of the body and the legs. The feet
bend forward slightly. Notice the
forehead dips inward.

3

Draw two arcs on top of the head for the rhino's ears. Draw two horns (one small and one large) on the lower left side of the head, and then draw a small line suggesting the nose and a round circle for the eye. Going back to the feet, draw what can be seen of the nails.

4

Erase some of the initial guidelines and work on the final, general shape of the rhino. Draw some lines for wrinkles.

5

Add a few more details and little wrinkles on the muzzle and more lines around the eyes and in the places on the body where the skin folds. Draw quick, short strokes on top of the ears to represent hair as well as a few lines inside the ears.

6

Add a layer of color all over the rhino's body and let it dry. Add a slightly darker layer of color in the shaded areas of the body to give it more volume.

DRAWING
ELEPHANTS
the largest on land

THE LARGEST of all land-dwelling animals, elephants display unique physical features and behaviors. In addition to their sheer size, their trunks, tusks, and wrinkled skin are particularly prominent. Elephants use their muscular trunks for breathing and smelling, eating and grasping objects, greeting one another, and as a snorkel when they swim. Similarly, they have multipurpose tusks used in digging for water and roots, for peeling back bark from trees, and for defense during combat. Their thick, wrinkled skin keeps them comfortable in often harsh environments, and they actively cover themselves in mud to ward off parasites and sunburn.

Elephants' brains are large and complex, like those of primates and cetaceans, supporting their sophisticated communication and social behavior. Females live in large, matriarchal herds of related individuals, while males are solitary or live with other young bull elephants. They communicate with one another in a variety of ways, including through scent, sound, and physical displays. Interestingly, they can send messages over great distances by using infrasound, or low-frequency rumbling, that travels through the ground. Elephants form incredibly strong bonds and care for their young longer than any other animal, besides humans.

Quick Guide to
DRAWING ELEPHANTS
. .
Draw large ovals for the head and body.

Pay attention to proportions.

Add basic shapes and lines for the legs,
ears, trunk, and tail.

Refine the outlines of the body and limbs.

Add lines to show the texture of the skin.

Add color and shading
for dimension.

› **HOW TO DRAW** ‹

AFRICAN BUSH ELEPHANT

Loxodonta africana

Getting an elephant's basic shapes down is relatively easy; refining those shapes and adding wrinkles, other surface details, and shading are trickier but will result in a more polished drawing.

The largest of all elephant species, African bush elephants are found in woodland and savanna habitats across the African continent. Unlike their Asian counterparts, tusks are present on both males and females, and their stunning cognitive abilities include memory, cooperation, playfulness, and tool use. They face increasing threats in the wild due to poaching for ivory and human–elephant conflicts, especially around the raiding of crops.

1

Begin by visualizing the elephant as a whole, noting its proportions and primary shapes. Draw a large oval as a basic guide for the body and a smaller one for the head.

2

Block in the legs and ear with basic geometric shapes. Pay attention to proportion, as these shapes will become the basis for adding details later.

3

Draw thin lines to suggest the position and direction of the tail, trunk, and tusk, and to connect the areas above and below the ear to the legs and body.

4

Outline the basic shapes to strengthen the elephant's silhouette and give it character. Add the eyes and develop the face, tusk, and trunk. Add a tree branch to the trunk, if desired. Note how the trunk curves around the branch like a spiral toward the end.

5

Develop the feet by refining their shapes and adding toenails. Note that the very bottoms are wider and bulkier than the tops, to give the elephant support for its large frame. Create texture by adding lines—longer ones on the body, shorter ones on the trunk—and add a few leaves to the branch.

6

Add volume and movement with a light wash of watercolor, ink, or gouache to create shadows on the body, legs, trunk, and around the ear, as well as on the branch's leaves.

Quick Guide to
DRAWING BURROWERS
..........................

Create a few basic shapes to define
the body proportions.

Use the main guidelines to build
the overall structure of the body.

Capture surface details by adding short,
sharp lines all over, except for
the head and feet.

Add color and texture with
short brushstrokes.

DRAWING
BURROWERS
the odd coupling

PREVIOUSLY GROUPED under the name *Insectivora*, this group of small mammal species is now called *Eulipotyphla*, meaning "truly fat and blind," and includes animals such as hedgehogs, moles, moonrats, and shrews. Most eulipotyphlans are underground dwellers with poorly developed eyesight, but their exceptional hearing and sense of smell help them thrive in often-dark environments. They are mostly solitary and nocturnal, and though their previous group name suggests a strict insectivorous diet, most are omnivorous, actively taking earthworms, snails, roots, berries, nuts, and even small vertebrates.

Moles are best known for their large, clawed front paws that allow them to dig extensive burrows, but lesser known for their toxic saliva capable of paralyzing earthworms and other prey. Closely related to the moles are the widely distributed and extremely diverse shrews, making homes on almost every continent in the world. Shrews are incredibly territorial and possess venom that is delivered to prey through tiny grooves in their teeth. Hedgehogs are also amazing diggers, and are easily recognized by their long snouts and pointy quills. Closely related to the hedgehogs are the moonrats, also known as gymnures. They are ratlike in appearance and largely carnivorous, actively hunting arthropods and small vertebrates such as rodents, amphibians, and reptiles.

> HOW TO DRAW ‹

EUROPEAN HEDGEHOG

Erinaceus europaeus

Similar in some ways to the armadillo, this spiky fun little animal is easy to draw once you figure out the basic shapes. Create texture and volume by using long brushstrokes.

This amazing digger is widely distributed throughout Europe, from Scandinavia to the Mediterranean Sea, and is best recognized by its unique fur that has been modified into quills. Equipped with incredible hearing and sense of smell, it feeds almost exclusively on invertebrates, and makes use of a special defense when threatened, tightly tucking its appendages into a ball, exposing only its erect quills to would-be predators.

1

Draw a large oval suggesting the hedgehog's body and a smaller one on the lower side for his head.

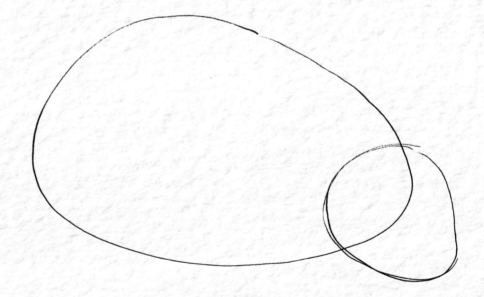

2

Draw a few guidelines for the positioning of the feet and paws, and then place the eye on the side of the head. Add two curves to suggest the pointy nose and two triangles (a larger one and a smaller one) for pointy ears.

3

Add straight lines along the main oval drawing to suggest the hedgehog's stiff spines. Draw a small dark circle for the (visible) eye and a black round nose at the end of the snout. Define the short legs and the clawed feet.

4

Draw spines all over the body, except the face and feet.

5

Add a light cream color all over your drawing and let it dry. Add a more pinkish cream color to the feet and snout. Let it dry again.

HEDGEHOG AND ARMADILLO SIMILARITIES

· ·

Both insectivores, the hedgehog and the armadillo share the camouflage qualities of their beautifully patterned back shells. While the hedgehog has long, spiky spines, the armadillo's armored shell has a pattern that looks like rows of dots and triangles. Both animals roll up and hide when they feel threatened.

6

Add brown strokes to the spine area and the tip of the snout. The spines are often brown with lighter tips, so leaving some of the areas in the initial cream color will help you suggest that. The hair on the belly is white. If you wish, erase some of the spines drawn in pencil.

7

Finalize all the spine strokes and darken the snout area close to the nose.

Quick Guide to
**DRAWING
RODENTS AND RABBITS**
..........................

Draw basic shapes to suggest
proportions and movement.

Work over the initial guidelines
to gradually add details.

Refine the main drawing by adding
short strokes to develop fur.

Add color to create volume and
enhance surface texture.

DRAWING
RODENTS
AND RABBITS
the most diverse

REPRESENTING nearly half of all mammal species, rodents are extremely diverse in behavior, habitat preference, and diet, and have successfully colonized ecosystems on every continent but Antarctica. From the 100-pound (45 kg) capybara to the tiny 0.1-ounce (3 g) pygmy jerboa, rodents are best known for their ever-growing incisors, used for gnawing and digging, and their complex social structures that range from tight-knit family groups to large colonial towns and class-based societies. They also adhere to a large variety of mating systems, from monogamy to polygyny, and often produce large litters to maximize the chance of survival for at least some offspring. Though often looked upon as disease-spreading pests, many rodents perform critical functions in ecosystems, most especially as seed dispersers.

Closely related to the rodents, though much less diverse, are the lagomorphs, a group containing rabbits, hares, and pikas. Unlike the varied diets of rodents, lagomorphs are strictly herbivorous and make use of hindgut fermentation to aid in digestion and nutrient absorption. Their commonalities with rodents are many, including ever-growing incisors, wide global distribution, production of multiple large litters throughout the year, and their critical role as an important food source for other animals.

› HOW TO DRAW ‹

CHINCHILLA

Chinchilla lanigera

The chinchilla is a gray, furry animal, quite cute looking and a bit like a mouse. Create fur texture by adding a few layers of paint one at a time. Notice the very long whiskers and bushy tail.

Native to the mountains of South America, chinchillas are medium-size nocturnal rodents well adapted for a high-elevation lifestyle. Offspring are born ready to face the world with eyes wide open and a thick coat of dense fur, the latter trait in such high demand that overhunting has threatened chinchilla species with endangerment and even extinction.

1

Draw two basic circles as guides for the chinchilla's head and body. Draw a line to suggest the direction and length of the tail.

2

Draw a circle for one of the ears and an arc for the other ear that's behind. Draw a few guidelines for the front legs and the longer back legs. The chinchilla's tail is short, but very bushy/hairy.

3

Using curved lines, connect the
major shapes to finish the main
outlines of the animal's body.
Add a round circle for the eye
and a few more lines around it
for extra details. Suggest
the fur on the tail with long,
sharp strokes.

4

Refine your main drawing with
more details that highlight the
fur and add long, stiff whiskers.

5

Once you're happy with your
drawing, add a first layer of paint,
leaving the area around the eyes
lighter. Note that the normal
wild-type chinchilla's color is a
smoky blue-gray.

6

Give your painting more dimen-
sion and volume with a second
layer of painted details once
you first layer is dry. The fur on
the back and top of the head is
darker. You can give the tail more
volume by adding darker paint
strokes on it. The inside of the
ear is a light gray-pink.

› HOW TO DRAW ‹

CAPE HARE

Lepus capensis

Long ears and legs with an athletic body,
the Cape hare comes to life by adding color and
creating texture with your paintbrush.

*Widely distributed across regions of Africa, Asia,
and the Middle East, the Cape hare is well adapted
to life in arid environments. Nocturnal and strictly
herbivorous, it feeds primarily on grasses and shrubs,
and reingests its own feces to absorb extra nutrients.
Females birth multiple litters each year and the
young are born fully furred and ready to move.*

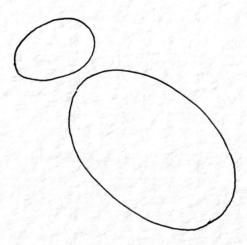

1

To draw a hare, start with two ovals,
a smaller one for its head and a larger
one for its body.

2

Take a close look at the model you are
planning to draw and notice specifically
how the large ears and legs are
positioned. Trace a few guidelines.
Draw ovals for the hare's breast
and hindquarters.

3

Refine the shape of the hare by drawing
around your guidelines, drawing a circle
for one of the eyes.

4

Continue observing and add a few other
details to refine your drawing more.
When drawing the eye, add a little circle
in the center representing the pupil
and a tiny circle on the side representing
the highlight.

5

Add a few quick, short strokes around
the body representing the texture of the
fur. Refine the eyes more, and add whis-
kers and some shading inside the ears.

6

As an extra option, add a soft layer of
brown (watercolor or gouache) all over
the hare's body, except the eye and the
inside of the ears. You can paint the
inside of the ear with a soft pink.

7

Once your first layer of color is dry,
paint a darker layer of brown on the
back of the hare. Paint the tip of the
ears darker, as well, and add more
shading around the body. Paint the eye
a beautiful, bright brown.

DRAWING
SLOTHS
slow movers

THE SLOTHS, anteaters, and armadillos of the world are grouped together under the name *Xenarthra*, meaning "strange joints" due to the unique structure of their lumbar vertebrae. They occur predominantly in Central and South America, with one species, the nine-banded armadillo, ranging into the southern United States. Nearly all are solitary, have uniquely low body temperatures and metabolic rates, and no enamel on their teeth. Sloths are best known for their slow pace and incredible tree-climbing abilities, while anteaters are better recognized by their long snouts and tongues and large, powerful front claws. Armadillos are best characterized by their bony shell of armor, and they display an amazing range in size across species, from the 5-inch (12.5 cm) pink fairy armadillo to the 5-foot (1.5 m) giant armadillo.

All sloths are herbivorous and practice hindgut fermentation, while anteaters, as the name suggests, are strict insectivores, feeding primarily on ants and termites. Armadillos, on the other hand, are true omnivores, taking a variety of foods across habitats as the seasons change. Though sloths and anteaters usually produce only one offspring, armadillos are capable of larger litters. In fact, within some species, a single fertilized egg can divide multiple times, producing an even-numbered litter of genetically identical babies.

› **HOW TO DRAW** ‹

BROWN-THROATED THREE-TOED SLOTH

Bradypus variegatus

As you sketch your drawing, make sure you focus on the proportions of the arms and legs compared to the body. Pay attention to the head details and the movement of the fur, as they make the sloth quite different from other creatures.

Among the slowest of all mammals, this species almost never leaves the trees and sleeps up to 20 hours a day. Its leaf-based diet mandates unusually low metabolism and body temperature, and its thick fur is home to a variety of commensal species of algae and fungi, the former producing a greenish hue that acts as camouflage against the forest backdrop.

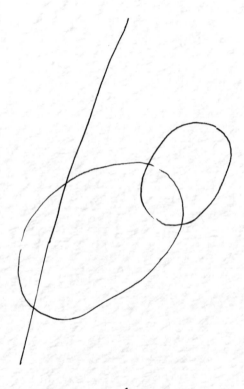

1

Draw two ovals as guides for the sloth, a smaller one for the head and a larger one for the body. Draw a line to suggest the positioning of a branch that the sloth will be climbing on.

2

Sketch a few more lines to help you with
the positioning of the long arms (only one
of them will be holding the tree branch)
and the legs, which hug the tree branch.

3

Section the head in two by drawing a line
down the middle. This will help you symmet-
rically add two circles for the eyes, the nose
with the nostrils, the mouth area, and the
patches around the eyes. Draw a series of
curved lines to show the long, curved claws
(with pointy ends) that wrap around the
branch. As the name suggests, the sloth has
three clawed toes on each limb.

4

If you wish, you can erase some of the initial
pencil guides and leave only the final ones.
Add more details around the head area.

5

Add some shading on the sloth to give
it more dimension by suggesting the fur
texture. Color the patches around the eyes
and color the nose black.

6

Add a layer of warm gray paint all over
the body, except the area above the eyes
(forehead) and a bit around the mouth.

7

Paint the darker areas with black-gray and
paint a few more long strokes for the fur,
especially in the areas that are in shadow.

Quick Guide to
DRAWING BATS
· · · · · · · · · · · · ·

Sketch a few essential shapes and lines
to create the iconic outline of the body.

Pay attention to the scale of each body
element and the architecture of the wings.

Define the details and lines
along the furry body.

Add layers of color for
volume and depth.

DRAWING
BATS
true flyers

LIKE RODENTS, bats are extremely diverse, representing approximately 20 percent of all known mammal species. They are also widely distributed, found in every region of the world except those that are very isolated (some islands) and very extreme (too cold or too hot). As a group, bats make use of a variety of food types, including nectar, fruit, insects, small vertebrates, and blood. Most bat species are nocturnal insectivores with poor eyesight that rely on echolocation to hunt and navigate, but the fruit bats have evolved excellent eyesight and sense of smell to successfully locate food. Bats vary in size, from the tiny bumblebee bat of Southeast Asia (weighing less than 1 ounce [28 g]) to the giant golden-capped fruit bat of the Philippines (weighing almost 4 pounds [1.8 kg]).

Though there are several mammals capable of aerial gliding, bats are the only mammal capable of true flight. Bat wings are functionally similar to those of birds, but they are not the result of common ancestry (a prime example of convergent evolution) and are built around different bones. Female bats use several reproductive strategies to maximize survival of pups, including sperm storage, delayed implantation, and controlled delay of fetal development. Bats are vitally important, playing ecological roles in seed dispersal, pollination, and the control of pest insects.

› HOW TO DRAW ‹

BLACK FLYING FOX

Pteropus alecto

An amazing creature of the night, the black flying fox has very specific guidelines and proportions to consider. Due to the construction of their wings and their iconic look, bats make a fun drawing subject.

Native to Australia and parts of Southeast Asia, the black flying fox is a large, nocturnal bat that feeds on pollen, nectar, and fruit plants. Despite its large size (wingspan of more than 3 feet [91 cm]), it often lives in roosts of many thousands of individuals. It faces public scrutiny for its role in damaging fruit crops, especially in times of drought, and as a vector for disease.

1

Draw a circle for the head and an oval for the body. Sketch the bat's upper arms, forearms, and wing position on each side of the body.

2

At half of the length of the wings, draw three lines on each wing that will determine the position of the bat's finger bones. Sketch a few lines for the legs and feet.

3

Add two small circles for the ears. Refine the arms and legs. Organically connect the bat's fingers to create the membrane of the wings. Take a close look at how the wings are formed.

4

Draw a pointed nose for a doglike
face and two circles for the eyes.
Refine your drawing overall, paying
attention to the width of the fingers.

5

Draw short strokes to represent
the fur. Add more details to the
eyes and wings.

6

Add the first layer of color,
a dark gray.

7

Once your first color layer is dry,
paint a second one that focuses
on making the body and the finger
bones darker. Continue adding paint
strokes to give it more volume and
to suggest the furry body.

DRAWING
PRIMATES
among the trees

CONSIDERED by many as the most advanced of all mammals, primates exploit a wide variety of habitats throughout the world, with most inhabiting tropical and subtropical areas of Africa and Asia, as well as North, Central, and South America. Currently represented by two groups, the wet-nosed primates (also called strepsirrhines) contain the lemurs, bush babies, pottos, and lorises, while the dry-nosed primates (also called haplorhines) contain the tarsiers, apes (including humans), and Old and New World monkeys. While all primates possess certain distinctive traits, including opposable thumbs, enlarged brains, stereoscopic vision, and collarbones, as a group they exhibit incredible variation in size, locomotion, social structure, communication, and food preferences.

Primates are known for their complex social interactions and amazing cognitive abilities. In some species, females disperse away from natal grounds upon maturity, while in others it is the males who leave. Some species build their societies around one monogamous breeding pair, while others are considered more solitary. Many species partake in cooperative behaviors like sharing of food, mutual grooming, and coordinated defense against predators. Primates are also one of the only animal groups known to make and use tools, most often for hunting and food collection. Most primates mature more slowly than other mammals but, in turn, also experience extended life stages and longer overall life spans.

Start with basic shapes that will
serve as guides for your drawing.

Define the placement and proportion of
each body element, including the long tail.

Add special facial features and
other details on the body.

Paint a few layers of color to
enhance dimension and define
the texture of the fur.

› HOW TO DRAW ‹

SQUIRREL MONKEY

Saimiri sciureus

Although there are many species of monkeys, noticing the specific details and characteristics as you begin your drawing will make the squirrel monkey unique. It's also important to notice the different color variations and face/head features.

The squirrel monkey is a small, diurnal primate that lives in the tropical rainforests of Central and South America. Though not very vocal, it is a highly social species that spends most of its time foraging for fruits and insects, also taking leaves, seeds, and the occasional small vertebrate. Mating occurs during a short breeding season, after which females birth one offspring and males offer no parental care.

1

Using what we have been practicing so far, draw a few initial shapes to serve as guides for your illustration. Define the position of the monkey and the location of the head, body, arms, legs, and long tail.

2

Continue adding more guidelines to define the ears, the mouth area, the thickness and curve of the arms, the legs, and the tail.

3

Add the eyes, nose, mouth, long
fingers, and toes. Sketch a branch
for the monkey to perch on.

4

Once you have the main elements
drawn, you can start adding details
and slowly erase or draw over
some of the initial guidelines.

5

Continue defining the eyes and
ears, and suggest some fur on the
body using short pencil strokes.

6

Add a layer of brown paint all over the drawing, excluding some parts of the mask on the face, the ears, and the belly.

7

Once your first paint layer is dry, add a few more brush-strokes to create more texture through fur and shading. The fur on top of the head, the back of the neck, the shoulders, the upper legs, and the end of the tail has a darker brown color.

› **HOW TO DRAW** ‹

RING-TAILED LEMUR

Lemur catta

With a long and easily recognizable tail, the lemur is a charming animal to draw. Pay attention to the details that make it different from other primates.

The most recognizable of all lemurs (the most endangered primate in the world), the ring-tailed lemur is a highly social, diurnal omnivore that exhibits complex scent and sound communication. Endemic to Madagascar, it is considered ecologically flexible (able to exploit many different habitat types) and is critically endangered due to issues with habitat destruction, poaching, and the pet trade.

1

Take a close look at the proportions of this beautiful animal. Draw a circle for the lemur's head and a large horizontal oval for the body. Sketch the position of the long arms and legs, suggesting also the base of the paws and feet. Draw a long, slightly curved line (like the letter S) pointing up for the tail; it should be almost twice the height of the animal.

2

Use your previous guidelines to refine the shapes around the body. Draw two ovals for the ears, two small circles for the eyes, and suggest the positioning of the nose and mouth. The tail is not only long, but also quite thick and fuzzy. Define the arms and legs, as well. Notice that the top line is bent because of the lemur's arched back.

3

Draw the lemur's nose, which consists of two lines for the nostrils, and then draw a line in between them. The eyes are surrounded by two black patches; you can sketch the shape around the area so you can later fill it in with color. Add curved lines to the tail to suggest the rings. Draw a few lines to suggest the fingers and toes.

4

Add short strokes on the body to suggest fur, and color the patches around the eyes and the top of the head black. Refine the black-and-white rings on the tail, taking into consideration that the tip of the tail will be black.

5

Add light brown or gray layers over your drawing, excluding the head, which is mostly white. The belly area is paler than the rest of the fur.

6

Once your first layer of color is dry, add a few more tones of black on the nose and head, inside the ears, on the area behind its neck, and on the tail rings. You can color the eyes with a bright brown or ochre/yellow.

Quick Guide to
DRAWING MARSUPIALS
. .

Draw a few guidelines such as circles and
connecting lines to reveal the shape and
position of the body.

Refine the special facial features as well
as the furry ears, body, limbs, and feet.

Add color, leaving some areas white
for the light-colored fur.

Add more brushstrokes to
fine-tune the fur.

DRAWING
MARSUPIALS
young in pouches

ENDEMIC TO the Australian continent and the Americas, marsupials are named for the distinctive pouch, or marsupium, in which most carry their newborn young. Most marsupials occur in and around Australia, including well-known species such as koalas, kangaroos, and wombats. Nearly all marsupials are nocturnal, and they are surprisingly diverse in size, habitat preference, and food source, from the scavenging devil of Tasmania, capable of eating an entire carcass including the bones, to the carnivorous Ningbing, an adorable but ferocious invertebrate predator restricted to one small region in northwest Australia.

Marsupials have evolved excellent hearing and sense of smell, important features for animals that make their way primarily at night. Newborn marsupials, also called joeys, are born extremely small and undeveloped, and are not capable of regulating their own body temperature. After birth, they must crawl their way to the safe environment of the mother's pouch, where they will latch onto a nipple and continue developing for many months more. Most marsupials are solitary, coming together only during the breeding season, and most give birth to multiple joeys at a time. They play many important ecological roles, including pollinator, seed disperser, pest controller, and burrow digger.

KOALA

Phascolarctos cinereus

A lovely animal to draw, the koala has
distinctive traits that make it stand out. Pay special
attention to the main body shape, the big fluffy ears,
the rectangular black nose, and the sharp claws
that help the koala climb trees so well.

*Native to Australia, koalas are nocturnal marsupials with
myriad adaptations for arboreal living. Specialized digits
and sharp claws help them cling tightly to branches,
ideal for an animal that feeds exclusively on the leaves
of eucalyptus trees. Though these leaves are toxic
to most animals, koalas can break them down, but their
low nutritional content provides minimal energy, and
consequently koalas spend most of their day sleeping.*

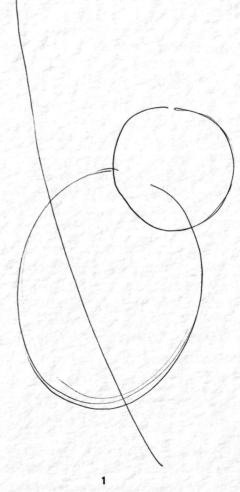

1

Start drawing this beautiful animal by creat-
ing a few guidelines first. Draw two ovals, a
smaller one for the head and a larger one for
the body. Almost halfway across the body
oval, draw a diagonal line that represents the
branch that the koala will cling to.

2

Draw two large circles on each side of the
head; they will be the koala's large ears.
Draw an oval for the large nose and two
small ones for the eyes. Sketch a few lines
suggesting the position of the arms and legs.

3

Define the thickness of the tree branch and
draw the arms with fingers gripping around
it. The feet will also grip the branch, but the
toes will be more visible. Add more details
to the mouth area, ears, and eyes.

4

Refine your final lines based on your
initial guides. Notice that the ears are
quite large, with long, shaggy fur.
The fingers and toes have strong,
long claws perfect for gripping
and climbing.

5

Add more fur details on the body and
a bit of texture on the tree branch.
Add a few leaves, if you wish.

6

Add a layer of warm gray on the body, excluding the areas inside the ears, around the mouth, the eyes, the belly, and under the arms, which have white fur.

7

Create more volume by adding a bit more color in the shadowed areas, and paint the eyes, nose, and nails black.

AMPHIBIANS

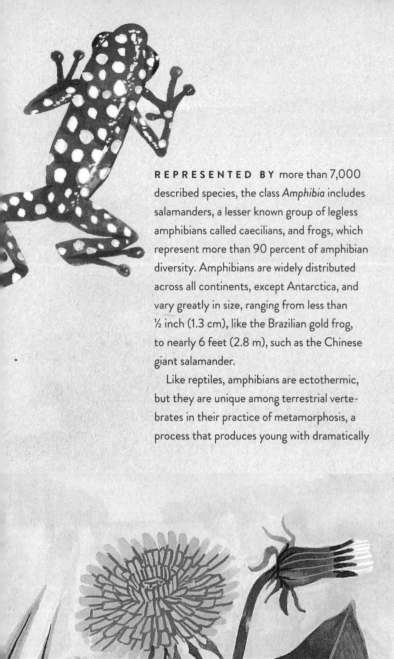

REPRESENTED BY more than 7,000 described species, the class *Amphibia* includes salamanders, a lesser known group of legless amphibians called caecilians, and frogs, which represent more than 90 percent of amphibian diversity. Amphibians are widely distributed across all continents, except Antarctica, and vary greatly in size, ranging from less than ½ inch (1.3 cm), like the Brazilian gold frog, to nearly 6 feet (2.8 m), such as the Chinese giant salamander.

Like reptiles, amphibians are ectothermic, but they are unique among terrestrial vertebrates in their practice of metamorphosis, a process that produces young with dramatically different physical and behavioral characteristics from those of adults. The life cycle of most amphibians is characterized by an aquatic egg stage that develops into an external-gilled larva before developing into a lunged adult. Interestingly, some species have evolved direct development, where they skip the larval stage altogether and hatch directly into miniature-size adults.

Amphibians play many important ecological roles in the habitats where they live, most notably as prey items, as predators of pest species, and as indicators of overall ecosystem health. They are also well known for their vocalizations, which serve a variety of functions, and, for frogs and toads in particular, can be critical to breeding success. For nearly all frog species, fertilization is external, with females depositing eggs into habitat, which males then fertilize with sperm. The opposite is true for salamanders, with most species exhibiting internal fertilization. Parental care of offspring

in amphibians is rare but not completely absent, as some species do actively protect their eggs and young.

One distinct feature of amphibians that can be difficult (but not impossible!) to re-create is their moist, porous skin. Unlike other terrestrial vertebrates, amphibian skin allows for the exchange of gas and water and contains numerous embedded glands for the production of mucus and toxins. Also, the skin's coloration often plays an important role in defense through camouflage and warning. It takes a patient and conscientious artist to accurately capture the unique blend of moisture, color, and topography that characterizes amphibian skin.

DRAWING
FROGS
AND TOADS
double life

FROGS AND TOADS belong to the order *Anura*, a group of nearly 7,000 described species representing the majority of amphibian diversity. Anurans are tailless in their adult form, and widely distributed throughout multiple habitat types on every continent but Antarctica. Almost all frogs have smooth, moist skin and long legs, but toads represent a subset of species with drier, bumpier skin and shorter legs. Most adult anurans are carnivorous, feeding primarily on invertebrate prey, and they breathe both with lungs and through their skin. Like other amphibians, they act as a common food source for many animals, so they rely on a variety of defense mechanisms, including elaborate camouflage, aposematic coloration to advertise toxicity, and the ability to jump fast and far from would-be predators.

One prominent feature of anurans is the incredible diversity of vocalizations that they create and broadcast to attract mates. Many species produce additional calls for other reasons: to guard territories, signal danger, announce upcoming rainfall, or declare their disinterest in breeding. For most anurans, fertilization occurs externally, with a male mounting and holding tightly to a female, sometimes for extended periods of time, until she releases her eggs and he deposits his sperm cloud on top. Fertilized eggs develop into gill-breathing tadpoles, the tailed stage of the anuran life cycle, followed by metamorphosis into adult frogs.

Quick Guide to
DRAWING
FROGS AND TOADS

.....................

Establish the main outline of the body
by sketching a few basic shapes and lines.

Look closely at proportions and the
construction of the limbs and digits.

Finalize the lines that define the entire
shape and then add details.

Paint a few layers of color to impart
volume and clearly represent
each surface texture.

› **HOW TO DRAW** ‹

BLUE POISON FROG

Dendrobates tinctorius

Although poisonous, these elegant little frogs make very delightful drawing subjects. Their vast variety of bright, stunning colors and patterns makes them some of the most beautiful frogs to paint.

Native to the tropical rainforest habitats of Central and South America, blue poison frogs display some of the most dramatic and spectacular color patterns of the entire animal kingdom. Most species are small (less than 1 inch [2.5 cm]), all are active in the day, and all use bright coloration to advertise their skin toxins, which they derive from the invertebrates they eat, to would-be predators.

1

Start by drawing two ovals, a smaller one for the head and a larger one for the body.

2

Connect the two ovals and sketch a few thin lines as guides for the front limbs. Sketch the back limbs like horizontal V's ending with the digits. Find and sketch the position of the eye by drawing a small circle.

DRAWING WILD ANIMALS

· 98 ·

3

Each limb has four long digits (in this perspective, there are only three visible digits on one of the front limbs) that end in small circles that represent the toe (adhesive) pads.

4

As you follow your first guidelines, refine the final shapes of the thin areas of the front and back limbs. Use a series of lines to also refine the main shape of the body. Add a few bumps on the back of the frog, and note that the back line goes straight down.

5

Draw the big, dark (visible) eye as well as a curved line above it to define its structure. Draw another curved line to create the bump above the eye in the background, which is not visible. Finalize the lines that define the whole shape of the frog and add a few small dots as part of the texture of the skin.

6

We will paint this dart frog blue, so that is going to be our first layer of color.

7

Once your first layer of color is dry, continue to add a darker shade of blue in the areas that are in shadow; also add the dots on the back and on the head.

8

If you would like to add an extra effect of texture and dimension, use some white acrylic or gouache paint to draw small white dots along the body, head, and limbs. This will give the frog that shiny effect and make it look more real.

Here are a few other amazing color variations that can be seen in poison dart frogs.

› HOW TO DRAW ‹

COMMON TOAD

Bufo bufo

An important part of drawing a toad is the texture of this amphibian's skin. Use layers of color and brushstrokes to create shading and indicate the bumps along the body surface.

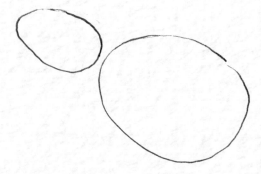

1

Draw two ovals as guides to represent the head and the body.

2

Connect the two ovals with two lines, forming an egg-shaped body so that the bottom part is much bigger. Add a few lines as guides for the toad's limbs and digits.

3

Draw the positioning of the eye, adding a curved line above the eyeball. Place the mouth and draw a few bumps on the back. Define the width of the limbs. The digits are a bit different than those of the poison dart frog, with the toad's being a bit thicker and bent toward the chest, with no round pads.

4

Refine the eye and add more details to the body.

5

Refine your main lines and add bumps and curved lines to represent the texture of the skin.

> **› TECHNIQUE TIP ‹**

EYE DETAIL: Draw the toad's eye by adding a smaller circle inside the eyeball, representing the pupil. Add a flat horizontal oval that intersects with the pupil, then draw them both black. Add one or two small white circles as highlights on the side of the iris and pupil.

6

Add the first layer of paint in a light brown. Let it dry.

7

Add a second layer of brown paint, focusing on the shaded areas and the bumps.

8

Add more color and dimension to your drawing, focusing again on the shadowed areas and bumpy body texture. Color in the iris with a light green.

DRAWING
SALAMANDERS
AND NEWTS
amphibians with tails

SALAMANDERS BELONG to the order *Caudata*, representing roughly 700 species distributed across much of the Northern Hemisphere and large portions of Central and South America. These tailed amphibians live in a variety of habitat types, including caves, forests, and burrows, but all depend on wet environments for part, if not all, of their lives. Most salamander species have smooth, moist skin, but newts represent a subset of species characterized by dry, bumpy skin that allows them to spend their adult lives on land, though they return to the water to breed and reproduce.

While some salamander species breathe through gills or develop lungs, most respire through their skin. All are carnivorous and incredibly opportunistic, eating virtually any animal they can fit in their mouths. Because salamanders also commonly serve as prey items, most have evolved skin toxins and warning coloration to ward off predators and are unique in their ability to regenerate lost or damaged body parts.

In stark contrast to their frog cousins, most salamanders practice internal fertilization, where males deposit a packet of sperm for females to pick up and hold internally until egg laying occurs. Development beyond the egg stage varies greatly across species, with some salamanders completing a larval stage before adulthood, some skipping straight to the adult stage, and others living their entire lives as larvae.

Quick Guide to
DRAWING SALAMANDERS AND NEWTS

.

Study the proportions and sketch the basic shapes.

Define the main curves of the long, slim body to reflect its movement.

Add lines to show skin texture.

Add color to define shading and create the effect of motion.

› **HOW TO DRAW** ‹

CALIFORNIA SLENDER SALAMANDER

Batrachoseps attenuatus

Understanding the body proportions and curves will help you draw this fun salamander. Add a touch of white paint in the right areas to create the shiny texture along the body.

Slender salamanders are found along the Pacific coastline from Oregon to Baja California, and are best recognized by their long, thin bodies with vertical grooves on the sides and tiny four-toed feet. Most often found beneath leaf litter and in small tunnels, these salamanders are most active from May to October. They breathe through their skin, and feed primarily on tiny arthropods.

1

Start with an oval to represent the salamander's head and neck, then draw a long line that curves into a reversed S for the shape and length of the body and the tail. Draw two circles along that line to mark the placement of the front and back legs.

2

Refine and adjust the width of the
animal by drawing curved lines
connecting your initial shapes.
The tail will gradually get thinner
toward the end.

3

Sketch a circle for the positioning
of the eye and add a few strokes
for the limbs.

4

Draw the width of the front and
back legs and draw the shape of
the mouth and more details on
the eyes.

5

Now that you have your basic
shapes ready, refine the final
lines and curves that go along the
salamander's body and add a few
textural details all over it.

6

Once your final drawing is ready,
add a layer of brown paint over
the entire body.

7

After your first layer of paint is dry, paint a slightly darker (or less diluted) brown and add shading and a few spots to help create some of the skin's texture.

8

You can add an extra layer of details and reinforce some shaded areas, as well. Once everything is dry, use white paint (gouache) or ink to add a few little light details on the body and a bit of highlight in the eye.

REPTILES

WITH MORE THAN 10,000 described species, reptiles compose one of the largest radiations of vertebrate animals. From the tiny dwarf gecko (less than 1 inch [2.5 cm]) to the massive saltwater crocodile (up to 18 feet [5.5 m]), reptiles display incredible diversity in size, shape, feeding habits, and habitat preference. They are found on every continent except Antarctica and include well-known groups such as lizards, snakes, turtles, and crocodilians. Reptiles are characterized by scaly skin, thermoregulation using the external environment, and, in nearly all species, young that hatch from eggs.

Reptiles rely on a broad range of food sources; some are strictly herbivorous, like most turtles and iguanas, while others are carnivorous, like snakes and crocodilians. Most consume meat and have many creative ways of catching prey, including ambush hunting, constriction, venom production, projectile tongues, and the ability to detect prey through vibrations in the ground and even underwater.

Reptiles have also evolved a wide variety of defense mechanisms, including camouflage, spiny body coverings, warning coloration, tail autonomy, the ability to change color, hard outer shells, and behaviors that make themselves look bigger or appear to be dead. Fertilization in reptiles occurs internally, with most species hatching their young from eggs, but some lizards and snakes perform live births. Newborn reptiles are fully developed and often face the world on their own, with only a small number of species providing parental care.

One defining feature of reptiles that may be challenging to replicate is the presence of scales, or scutes, on the outer body, sometimes overlapping and sometime not. Scales not only provide protection but can also aid in loco-motion, prevent water loss, and be modified into a variety of structures, including thorns, horns, and fringes. The many colors, shapes, and topographies of reptile scales offer ample opportunities for artistic engagement.

Quick Guide to
DRAWING
LIZARDS AND SNAKES
..........................

Using oval shapes and curved lines,
create the main contour of the body.

Refine the main outline by adding
details and specific features.

As needed, add specific skin patterns.

Apply color to suggest
camouflage, movement,
dimension, and texture.

DRAWING
LIZARDS AND SNAKES
scaly skin

FOUND ON EVERY continent except Antarctica, lizards and snakes unite to form the order *Squamata*, the second largest vertebrate order in the animal kingdom. To date, scientists have described more than 6,000 species of lizards, distinguished from roughly 4,000 species of snakes by their movable eyelids, ear openings, and in all but a few lizard species, legs.

Though lizards vary greatly in their food preferences (there are carnivorous, omnivorous, and herbivorous species), snakes are strict meat eaters, either actively hunting their prey or relying on ambush tactics. Though many squamates are exceptional predators, they are also important prey items for a variety of species, including birds, mammals, and other reptiles. They make use of a variety of innovative defense mechanisms, including the ability to drop their tails, squirt blood from their eyes, and spray or inject venom.

Squamates are often seen flicking their tongues in and out of their mouths; this is how most species smell and examine the environment around them. The tongue gathers chemical cues from the air, which are then processed by the brain through a specialized organ in the roof of the mouth. Snakes can also detect predators and prey through vibrations on the ground, and some can even sense the heat of other animals with specialized facial organs. Though most squamate offspring hatch from eggs, some species perform live birth.

› HOW TO DRAW ‹

GOLD DUST DAY GECKO

Phelsuma laticauda

Using the right details and colors to create the beautiful texture on this little creature's body will make it almost jump off your paper.

Native to Madagascar and parts of the Comoros and Seychelles Islands, this diurnal gecko is also encountered as an introduced species in Hawaii and neighboring islands in the Pacific. It is characterized by its brilliant green body, rusty bars on the head and back, blue toes and eyelids, and light dusting of golden spots. It is truly omnivorous, actively hunting small invertebrates and lapping nectar and pollen from flowers.

1

Draw a circle as a guide for the gecko's head and a long, flat oval for its long body. Add a long line that curves down at the end to represent the tail.

2

Suggest the lizard's muzzle by drawing a U-shaped arc connected to the head. Define the position of the eye, and draw a small circle and an arch above it. Connect the head to the body with two curved lines and draw the thick tail that gets slightly thinner at the end. Sketch the position of the legs and limbs.

3

Using your first lines as guides, draw the gecko's feet and digits. Add a few more curved lines to refine the main shape.

4

Add details on the body, drawing small dots all over for skin texture and slightly longer lines for the tail. Add a few spots on the back toward the tail. Draw the inside of the eye black, leaving a bit of white for highlight. The mouth line might make the gecko seem like it is smiling.

5

Add a bright green as your first layer of color.

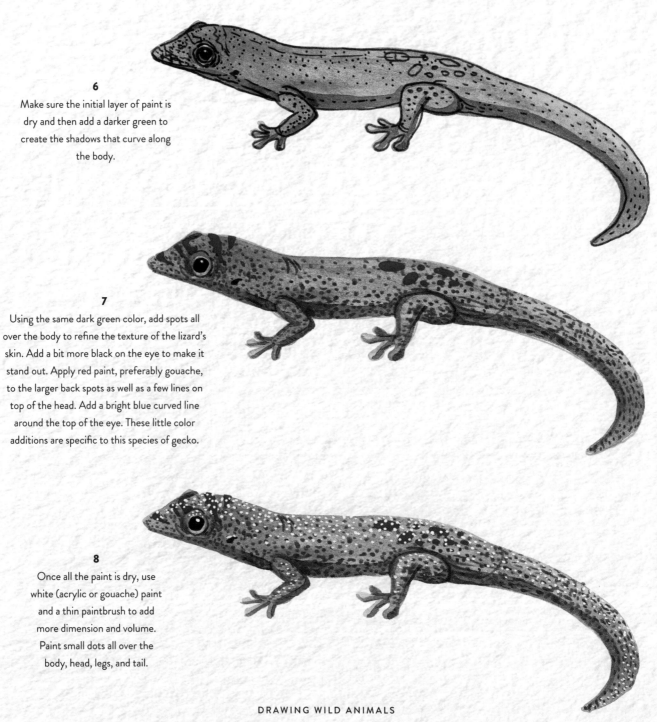

6

Make sure the initial layer of paint is dry and then add a darker green to create the shadows that curve along the body.

7

Using the same dark green color, add spots all over the body to refine the texture of the lizard's skin. Add a bit more black on the eye to make it stand out. Apply red paint, preferably gouache, to the larger back spots as well as a few lines on top of the head. Add a bright blue curved line around the top of the eye. These little color additions are specific to this species of gecko.

8

Once all the paint is dry, use white (acrylic or gouache) paint and a thin paintbrush to add more dimension and volume. Paint small dots all over the body, head, legs, and tail.

› HOW TO DRAW ‹

WESTERN DIAMONDBACK RATTLESNAKE

Crotalus atrox

This beautifully elegant, yet dangerous, reptile makes a very enjoyable subject to sketch, and especially to paint, because of its iconic diamond-like pattern and amazing skin texture.

Found throughout much of the southern United States and northern Mexico, the western diamondback rattlesnake has evolved many specialized features that make it an extremely effective predator. From its heat-sensing pits to its venom-delivering fangs, this species quickly and accurately strikes its intended prey, primarily small mammals, even in the dark of night.

1

Start by drawing a long, wavy line. At this stage, you are deciding how the snake will curve its long body. You can sketch just a few guidelines to determine how wide the head and the end of the tail—the rattle—will be. I chose this position to be able to have a clear look at the beautiful pattern on the rattlesnake's body.

2

On the initial guidelines, draw two ovals: a larger one for the head and a smaller one for the rattle at the end of the tail. Follow the basic curved path to draw the width of the whole body, which is slightly thinner behind the head, then remains the same until it connects with the rattle, where it thins slightly. Note that the last part of the body goes behind the front part as it curves into a loop toward the end.

3

Draw the rattlesnake's eye as a small circle inside a top arc, and draw a small arc toward the edge to suggest the other eye. Sketch straight lines at a perpendicular angle to the middle guideline. These will help you draw the pattern on the snake's body.

4

Sketch a little line to suggest the position of the snake's tongue. Using the straight lines along the body as guides, draw diamond shapes (a larger shape almost as wide as the body and a smaller one in the middle) to start defining the pattern. The diamond shapes will become only curves toward the tip of the tail/body.

5

Snakes are entirely covered with keratin scales. We can suggest that by drawing a few patches of scales here and there along the body and head. You can opt to draw the scale pattern all over the body, but this is just a matter of preference. Finish your main drawing by adding details to the head, the forked tongue, and the rattle. The rattle is formed of many little overlapping wavy lines, sectioned by a line down the middle, and they get smaller the higher up they go.

6

Once your final drawing is complete, add a layer of light brown all over the body.

> **› TECHNIQUE TIP ‹**
>
> Draw the scales as U-shaped curves. You can create a pattern by drawing a few of the U-shaped curves and skipping one in between. Draw the U-shaped curves in the second row under the spaces that you have previously skipped. Continue until your pattern is complete.

7

Add more volume around the snake's body by adding shaded areas in a slightly darker brown. Here, we assume that the light source is somewhere above the snake.

8

Once your last layer of color is dry, fill in the smaller diamond shapes along the body with dark brown paint. Paint a spot that starts under the snake's eye going toward the neck. Define the scales along the body with dark brown as well. Paint the snake's eye with a bright brownish yellow, leaving a small white circle for the highlight (or you can always come back with white paint if you cover it). Paint the tongue gray.

9

Use an even darker brown to paint around the diamond-shaped blotches on the body, forming a thick outline. Paint a few little rhombus-shaped spots in brown in between the large diamond shapes on the sides along the width of the body. This will define the overall pattern on the rattlesnake's skin. Paint some of the scales darker, focusing on the ones on the snake's head and around its mouth. Paint a dark brown line inside the eye as the slit pupil (a characteristic of venomous snakes).

Quick Guide to
DRAWING
CROCS AND THE LIKE
..........................

Draw simple ovals for the head and body
and then connect them with curved lines.

Continue defining the shape of the
head, mouth, limbs, and the length and width
of the tail (which may gradually get thinner
toward the tip).

Add more lines and details, focusing
on the design and geometrical shapes
of the scaled skin.

Add color, pattern,
and shading.

DRAWING
CROCS AND THE LIKE
"worm of stones"

WITH JUST A few dozen extant species, the order *Crocodilia* includes crocodiles, alligators, gharials, and caiman, a group of semiaquatic, carnivorous reptiles that are widely distributed in wetland habitats throughout the tropics and subtropics. Crocodilians are well adapted to life in and near water and are especially good swimmers, using their long tails like a paddle to propel themselves forward. They also have very keen senses, especially relative to other reptiles, with most of their sense organs situated on the top of the head so they can stalk prey above water while their large bodies remain hidden underwater. Even when fully submerged, they hear well and can sense movement in the water around them.

The ambush style of hunting that most species exhibit is both fascinating and terrifying to watch. While fully submerged, they patiently stalk land-based animals before snapping prey into their jaws and dragging it into the water, where they typically drown it, then swallow it whole. Some crocodilians are nocturnal while others are diurnal, but nearly all are solitary and actively defend territories as adults. As close relatives of birds, they show significant provision of parental care. Females of most species not only watch over and defend their nests, but they also transport their squawking young to water after hatching and actively protect them for the first part of life.

› HOW TO DRAW ‹

NILE CROCODILE

Crocodylus niloticus

You will use many geometric shapes when drawing this alluring creature, but the results will be wonderful because you will visually develop some of the most intricate skin patterns in the animal kingdom.

Widespread across much of the African continent, this extremely common aquatic species is among the largest of all reptiles, reaching lengths of 20 feet (6.1 m). It is a highly effective and patient ambush predator, waiting for just the right moment to snap its incredibly powerful jaws onto an assortment of would-be vertebrate prey, including fish, birds, mammals, and other reptiles.

1

Draw the guidelines for the head and the pointy mouth, which consists of two intersecting ovals. Slightly to the right draw a larger oval for the body of the animal. Sketch a few lines for the position of the feet, and then a long curve that will serve as the tail.

2

Connect your initial shapes and define the size of the tail. The tail is thicker coming from behind and gets thinner toward the end.

3

Refine the main lines around the crocodile's body. Add details such as the eye (with an arc on top), a (closed) mouth, a few skin bumps on the head and neck, and the feet with fingers/webbed toes at the end. Notice that the structure of the tail tends to be flatter on top, and all guidelines are gathering together toward the end, keeping the flat side on top.

4

Create a few lines intersecting horizontally and vertically, like a grid pattern, as guides for what will become the bumps on the crocodile's rough skin. Since we previously drew the main lines of the structure of the tail, draw the hard scales on the back and all the way to the end of the tail. Draw triangle-like shapes across the two main lines on the back of the crocodile, and then connect them to create the scale pattern. Create a few triangles and lines on the side as well.

5

Refine all the body parts, including the eyes, nose, the skin's rough bumps, a few dark spots on the body, and the mouth with the teeth. An important fact that differentiates crocodiles from alligators is that crocodiles have their teeth visible while their mouth is shut, while the alligator's teeth are hidden when its mouth is closed. Draw a few spiky triangle-like shapes to line the crocodile's mouth with teeth.

6

Add a layer of green color all over the body, except for the eye.

7

Once your first layer is dry, come back with more paint and add shading under the body and around some of the skin bumps, assuming that the light comes from the top left side. Color the eye with a lighter green.

8

Using a darker green, repaint over the scale structure to make it a bit more visible while contrasting with the green on the body. Use white paint (gouache or acrylic) to add a little dot as a highlight in the crocodile's eye and to paint in the teeth. Even a few little details such as these will give your drawing more life.

Quick Guide to
DRAWING TURTLES
AND TORTOISES
...............

Use ovals and curved lines as the basis for
the main outline and perspective of the body.

Add details to define movement and the
construction of each body element.

Study and sketch the design of the
scutes along the shell.

Draw the scaly, armored skin on the
head and legs.

Apply color one layer at a time
to add shading, dimension,
and pattern/texture.

DRAWING
TURTLES AND TORTOISES
bony plates and horny scales

THERE ARE MORE than 300 species of turtles and tortoises in the order *Testudines*, distributed across multiple habitat types in tropical and temperate regions. These toothless, egg-laying reptiles showcase a wide variety of lifestyles: some species are strictly aquatic, occupying niches from the open ocean to freshwater rivers and are generally referred to as turtles, while others are land dwelling from tropical rainforests to deserts and are generally referred to as tortoises.

Testudines are similarly diverse in their food preferences, with carnivorous, omnivorous, and herbivorous species as adults, but most immature testudines actively consume meat as a vital source of protein. Testudines are best characterized by their shells, which are firmly attached to the ribs and spine and covered in modified, overlapping scales called scutes. Typically, aquatic turtles possess smooth, hydrodynamic shells and tortoises possess more dome-shaped shells. The same is true for testudine feet; turtles generally have webbed feet for swimming (even flipper-like in some species), while tortoises generally have stumpy, clawed feet for walking on land.

All testudine species lay eggs and provide no post-hatch parental care. In many species, nest temperature plays a critical role in determining the gender of offspring, with warmer nests producing more females, and cooler nests producing more males.

› HOW TO DRAW ‹

RUSSIAN TOROISE

Testudo horsfieldii

Found in the wild from Kazakhstan to Pakistan, this small, herbivorous tortoise is active only for a small portion of the year, generally spring and summer months, during which time it forages and mates in a variety of arid habitats. Russian tortoises are considered sexually dimorphic, meaning males and females have many distinguishing features, and is a very common species in the global pet trade.

With a very elaborate shell (carapace) construction, the little Russian tortoise is very fun to draw and paint. Create beautiful results by understanding the design and patterns of the shell and body while adding extra dimension using color.

1

Sketch a little oval shape for the head and a larger oval (rocklike) shape that is flatter on the bottom for the turtle's body.

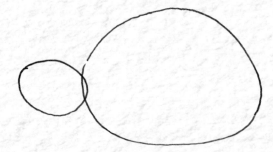

2

Draw a small circle for the position of the eye, and then draw a line that starts slightly above the head and curves down toward the end on the right. This will determine where the top shell (also called a carapace) will start. Draw a thin line for the bottom shell (called a plastron). Sketch a few lines representing the legs in a walking position.

3

Draw more details to define the head and wrinkly neck, and add a few sharp nails at the ends of the feet. Note that the scutes/scales are divided into three categories: the ones on top (middle of the shell) are called vertebral scutes (diamond shaped), the ones on the side are called costal scutes (octagonal shaped), and the lower, smaller ones are called marginal scutes (rectangular shaped). Begin to sketch these in.

4

Press harder with your pencil as you refine your final lines. Use the image reference, if needed, for the shell details.

5

Suggest the scaly, armored skin on the head and legs by drawing a series of irregular square shapes. Draw the eye black and add a few more wrinkles around the eye area and neck. Add more lines on the shell by drawing another set of shapes inside the ones you previously drew.

6

Once you are happy with your final drawing, add a layer of green or light brown.

7

Let your first color layer dry and then add dimension to the drawing by painting the shaded areas with a darker brown.

8

Add one final layer of brown color on the scales, the head, and the feet, and paint a thick outline around the scutes to give them more contrast. With a dark brown color, paint a few more wrinkles on the face and neck, the plastron, the edges of the scutes, and the nails.

› H O W T O D R A W ‹

GREEN SEA TURTLE

Chelonia mydas

This well-studied, migratory species is often seen gliding gracefully through tropical and subtropical oceans throughout the world. Adults travel great distances to reach breeding grounds where females deposit large numbers of eggs into dugout nests on the beach. After hatching, juveniles spend their first few years of life as carnivores in the open ocean, before shifting permanently to an herbivorous lifestyle in shallow, coastline waters.

Obviously like the Russian tortoise but on a larger scale, the green sea turtle requires the same attention to design and details. Notice what makes its large shell different from other testudines, and observe the mosaic-like skin patterns on the turtle's body and flippers.

1

The sea turtle will be looking up or swimming in the ocean to get to the surface. Start your first few guidelines by sketching a tilted oval for the head and a larger tilted oval for the turtle's shell (also called a plastron). Draw two oval-like shapes for the front flippers/feet.

2

Draw a few lines to connect the head to the flippers and the shell to create the neck. Sketch one of the rear flippers and refine the shell and front flippers a bit as well. Draw a line that points up at the end to suggest the sharp, beaklike shape of the mouth. The beak has finely separated edges.

3

Draw a circle for the eye and a few curved lines around it. Define the rounded mouth area with the scaled beak. Sketch the visible pentagon-shaped scales (also called scutes) on the side and what you can see of the central scales on the outer shell. You can look at the sketch on page 135 for reference.

4

Add texture to the skin and the flippers. Start by drawing a few oval-like shapes on the head all around the eyes for the scales and a few short lines along the neck for the wrinkly skin. Add scales on the flippers by drawing irregular octagons and square shapes that we will later fill in with color. Add a few more texture details on the shell as well. Draw the eye in black.

5

Once your drawing is done, add a layer of (diluted) olive green all over your drawing.

6

Once the first layer of color is dry, add a darker olive green to create shading under the shell, mouth, neck, and flippers, assuming that the light source comes from above.

7

Using a darker olive green, color in the scales on the turtle's head and shell, leaving space between them that will contrast with the lighter green underneath. Add a bit more shading under the shell.

8

Once your previous color layer is dry, use a darker green to define some of the scales on the turtle's face and color in the scales on the flippers. Again, leave space between your shapes as you color them, and it will create a beautiful pattern. Add details as needed to give more volume to your drawing.

> › **TECHNIQUE TIP** ‹
>
> Green sea turtles have four lateral scutes and five central scutes. The lateral scutes of the shell are nearly the same size as the central scutes.

CONSERVATION AND VALUE

SAVING SPECIES

Up to this point, we have discovered and celebrated the incredible diversity of sizes, shapes, colors, and lifestyles of terrestrial vertebrate species. While we observe and document the uniqueness of each species, we must also recognize a critically important characteristic that binds them all together: their inability to persist long term in the face of mounting pressure.

THE PLIGHT OF BIODIVERSITY

Scientists the world over agree that much of biodiversity, the whole of Earth's species, is in steep decline, with many labeling the current era as the next mass extinction (in fact, the current rate of extinction is up to 1,000 times higher than the fossil record). These declines are seen in habitats throughout the world, span both the plant and the animal kingdoms, and impact many of the terrestrial vertebrate species that we've introduced here. While there are many factors that contribute to modern-day extinction risk, the most notable and widespread are *habitat alteration*, *overexploitation*, *invasive species*, *pollution*, and *climate change*.

HABITAT ALTERATION refers to the way in which we, as humans, change the landscapes and ecosystems around us (distinguished here from natural habitat change through mechanisms such as earthquakes and volcanoes). Sometimes this change comes in the form of outright destruction for the development of cities and neighborhoods, but it also includes the removal of primary habitat to grow agricultural products, oftentimes in a monoculture. One prominent example is illustrated by the global palm oil industry, for which millions of acres of forest habitat have been converted to monoculture plantations, often in unsustainable fashion and at the peril of local plants, humans, and animals, including tigers, orangutans, rhinos, bears, and elephants.

OVEREXPLOITATION refers to the way in which we consume resources at unsustainable levels and includes activities such as hunting, fishing, and resource extraction. Overexploitation goes beyond the removal of species for mere subsistence, like the pet trade and specialty horticulture industry, and is well illustrated by sharp declines in global fish stocks over the past few decades. Also included here is the global demand and illicit market for wildlife products such as rhino horns, elephant ivory, and tiger bones.

INVASIVE SPECIES refers to the way in which we introduce varieties of plants, animals, and pathogens into regions of the world where they do not belong, in turn causing harm to native species and ecosystems. Showcase examples of the detrimental effects of human-mediated species invasions are seen through cane toads in Australia, Burmese pythons in the Florida Everglades, and mosquitoes in the Hawaiian Islands.

POLLUTION refers to the way in which we contaminate natural systems with detrimental products. Most often thought of as the introduction of waste and chemicals into the air, water, and land, this also includes light and noise pollution, as in the case of urban development near sea turtle nesting sites and petroleum extraction near polar bear denning sites in the Arctic.

Last, **CLIMATE CHANGE** refers to the way in which we are increasing the concentration of greenhouse gases in our atmosphere by burning fossil fuels, drastically altering our global climate patterns. Although some regions of the world are spared the detrimental effects of some human-mediated extinction risk factors, climate change is truly global and already impacts every habitat on the planet. Showcase examples of the impacts of climate change in natural systems can be seen in large-scale changes in species' ranges and migrations, phenological shifts across entire plant communities, and the decline in health of coral reef systems worldwide.

We are putting more pressure on species than at any other period in human history and, at the same time, we learn more every day about the inextricable link between human well-being and global biodiversity.

THE VALUE OF BIODIVERSITY

The constant flow of news and evidence supporting the precipitous decline in biodiversity begs the question of why it's important to conserve species in the first place. In other words, what is the value of biodiversity?

Scientists and philosophers alike often discuss this in terms of *intrinsic value*, or value regardless of what species provide directly to humanity, and *utilitarian value*, as determined by species' direct function and provision to humans.

Species hold intrinsic value from a variety of perspectives: in our longstanding cultural and religious connections to individual species, in the abundance of documented health and psychological benefits of time spent in nature, and in our demonstrated preference for recreation in and around natural spaces and biodiverse regions (in fact, ecotourism is the fastest growing sector of the tourism industry and has been for quite some time).

A more critical argument to make in this era of species decline lies in the direct, tangible benefits and services that we receive from other species, and from ecosystems more generally. These benefits are most often separated into two categories: *ecosystem products* are tangible goods that we harvest or create from other species, and *ecosystem services* are benefits that we receive from the very functioning of the ecosystems around us.

Food, medicine, and raw materials like wood and rubber are obvious products that we derive from other species, but what about the plethora of creative ideas offered by biodiversity? Often referred to as bio-inspiration, the borrowing of designs, methods, and materials put on display by nature is changing the way the world does business. From more vibrant digital displays to stronger body armor, ideas drawn from species are not only improving products from a user perspective but, also reducing the inefficiencies and waste historically associated with our design and manufacture processes themselves. We're quickly learning that other species, armed with millions more years of evolution, know how to do things better.

Although ecosystem products are visible and obvious, the more import-ant class of benefits comes in the form of ecosystem services. The benefits that we receive from the very functioning of local and global ecosystems are not only essential to human civilization, but are also, in nearly all cases, impossible to replicate with technology. Large-scale functions such as water regulation, waste treatment, pollination, and nutrient cycling are ab-solutely critical to human survival, though we often take them for granted and regard them as free. As we improve our ability to study the intricacies of the world around us, it becomes ever clearer that species do more for us than we do for them.

FROM APPRECIATION TO CONSERVATION

Acknowledging the critical link between species diversity and human well-being is an important step in the process of saving biodiversity, and it will take community members from all walks of life to slow the rate of extinction and save the species that we so admire and cherish. But hope is all around us.

Across the world, scientists, inventors, and educators, alike, are busy designing and implementing new strategies in the fight to conserve wildlife. Some are applying their passions to individual species, using genetic rescue techniques to save rhinos, large camera trap arrays to monitor jaguars, and new computer models that will prove key to the successful translocation of tortoises. Others are putting their talents to work in sustainable agriculture, converting abandoned warehouses into large-scale vertical farms, investigating new food products from unconventional sources like seaweed, and making better use of water through monitoring technology and research in desalination. Still others are working to inspire the next generation of conservationists, incorporating environmental education into every academic discipline, connecting everyday citizens to conservation projects in the field, and collaborating with communities to encourage pride and ownership for the protection of species worldwide.

Yet in the end, conservation begins with individual actions. As we explore the infinite wonders of the natural world, we grow fonder of the amazing species with whom we share this planet and learn to assess and mitigate our own impacts on the environment. In appreciating the unique and fragile beauty of these creatures all around us—our neighbors—we can begin to advocate on their behalf and create real change. So let us all get out there and discover species!

RESOURCES

PLACES

Anza Borrego Desert State Park | Borrego Springs, California

Corcovado National Park | Puntarenas, Costa Rica

Grand Teton National Park | Wyoming

Humboldt Redwoods State Park | Garberville, California

Manuel Antonio National Park | Aguirre, Costa Rica

Omaha's Henry Doorly Zoo and Aquarium | Omaha, Nebraska

Oswald West State Park | Arch Cape, Oregon

Ranomafana National Park | Madagascar

Redfish Lake | Stanley, Idaho

San Diego Zoo | San Diego, California

San Diego Zoo Safari Park | Escondido, California

Yosemite National Park | California

ORGANIZATIONS

American Museum of Natural History Museum | New York, New York

San Diego Natural History Museum | San Diego, California

San Diego Zoo Global | San Diego, California

REFERENCE AND INSPIRATION

Animal Encyclopedia | National Geographic

The Encyclopedia of Animals | David Alderton

The Encyclopedia of Animals | Dorling Kindersley

The Encyclopedia of Animals: A Complete Visual Guide | University of California Press

National Geographic | www.nationalgeographic.com/animals/index

Wildlife Reference Photos for Artists | wildlifereferencephotos.com

World Wide Fund for Nature | www.worldwildlife.org

ABOUT THE AUTHORS

OANA BEFORT is a Romanian-born, freelance graphic artist whose watercolor and mixed-media artwork is inspired by natural motifs and themes. She graduated from the National University of Arts in Bucharest, Romania, with a master's degree in graphic design and visual communication.

With her love for fresh colors and details, Oana transforms her passion for illustration and graphic design into whimsical stationery and paper goods that she sells in her Etsy shop. She has also worked with prominent clients around the world to create book covers, stationery, homewares, magazine illustrations, and more.

Oana currently lives in Council Bluffs, Iowa, with her husband and two kindred-spirit children. Living in a lovely area surrounded by natural beauty, they are often visited by many woodland creatures. To see more of Oana's work, visit www.oanabefort.com.

MAGGIE REINBOLD is director of community engagement at San Diego Zoo Global, heading up a dynamic team dedicated to designing and implementing programs that connect communities to conservation for the benefit of wildlife and habitats. She is also an adjunct faculty member in the biology department at Miami University, where she teaches the Earth Expedition to the Big Island of Hawaii. Maggie earned her bachelor's and master's degrees in biology at San Diego State University, with a focus on the population genetics of desert aquatic insects across the Baja California Peninsula. She has taught science in a number of formal and informal settings, including the San Diego Zoo Institute for Conservation Research, San Diego Natural History Museum, Cardiff Elementary School, and San Diego State University. As a National Science Foundation science fellow, she cotaught hands-on science with classroom teachers across San Diego County and spent several seasons in Arctic Alaska, bringing hands-on science education to unique and underserved communities on the North Slope. She lives in Poway, California.

INDEX

African bush elephants, 48–51
amphibians, 94–95
anurans, 96–97
armadillos, 56, 66

bats, 72–73
Bengal tigers, 16–18
biodiversity, 136, 138–140
black flying foxes, 74–77
blue poison frogs, 98–100
Brazilian gold frog, 94
brown-throated three-toes sloths, 68–71
bumblebee bats, 73
burrowers, 52–53

caecilians, 94
California slender salamanders, 106–109
Cape hares, 63–65
capybaras, 59
carnivorans, 15
chinchillas, 60–62
Chinese giant salamander, 94
climate change, 138
common toads, 101–103
conservation, 136–141
crocodiles, 122–123

dry-nosed primates (haplorhines), 78
duckbilled platypus, 13
dwarf geckos, 112

elephants, 46–51
elk, 30–33
eulipotyphlans, 53
European hedgehogs, 54–57
eutherians, 13

frogs, 94, 96–97

giant armadillos, 66
giraffes, 36–39, 40–42
gold dust day geckos, 116–118
golden-capped fruit bats, 73
gray wolves, 19–21
grazers, 28–29
green sea turtles, 133–135
gymnures (moonrats), 53

habitat alteration, 137
haplorhines (dry-nosed primates), 78
hedgehogs, 53
hippopotamuses, 33–35

invasive species, 137

joeys, 87

koalas, 88–91

lagomorphs, 59
lizards, 114–115

mammals, 12–13
marsupials, 13, 86–87
moles, 53
monotremes, 13
moonrats (gymnures), 53

newts, 104–105
Nile crocodiles, 124–127
nine-banded armadillos, 66
Ningbings, 87

overexploitation, 137

pink fairy armadillos, 66
poison dart frogs, 100
polar bears, 22–24
pollution, 138
predators, 14–15
primates, 78–79
pygmy jerboa, 59

rabbits, 58–59
reptiles, 112–114
rhinoceroses, 43–45
ring-tailed lemurs, 83–85
rodents, 58–59
Russian tortoises, 130–132

salamanders, 94, 104–105
saltwater crocodiles, 112
scavenging devils, 87
shrews, 53
sloths, 66–67
snakes, 114–115
squamates, 114–115
squirrel monkeys, 80–82
strepsirrhines (wet-nosed primates), 78

testudines, 129
toads, 96–97, 101–103
tortoises, 128–129
turtles, 128–129

ungulates, 29

western diamondback rattlesnakes, 119–121
wet-nosed primates (strepsirrhines), 78

yellow mongooses, 25–27